T0132028

To: _____

From: _____

A Child's Art

My First Attempts at Digital Art

KYRA

A Child's Art

MY FIRST ATTEMPTS AT DIGITAL ART

Copyright © 2022 KYRA.

All rights reserved. No part of this book may be used or reproduced by any means, graphic, electronic, or mechanical, including photocopying, recording, taping or by any information storage retrieval system without the written permission of the author except in the case of brief quotations embodied in critical articles and reviews.

iUniverse books may be ordered through booksellers or by contacting:

iUniverse
1663 Liberty Drive
Bloomington, IN 47403
www.iuniverse.com
844-349-9409

Because of the dynamic nature of the Internet, any web addresses or links contained in this book may have changed since publication and may no longer be valid. The views expressed in this work are solely those of the author and do not necessarily reflect the views of the publisher, and the publisher hereby disclaims any responsibility for them.

Any people depicted in stock imagery provided by Getty Images are models, and such images are being used for illustrative purposes only. Certain stock imagery © Getty Images.

ISBN: 978-1-6632-3526-8 (sc)
ISBN: 978-1-6632-3527-5 (e)

Library of Congress Control Number: 2022901809

Print information available on the last page.

iUniverse rev. date: 02/04/2022

To Mama and Papa…

Welcome!

The art that you will see is done by a kid who is trying to find an absolute art style despite that kid knowing it takes years of practice to be good in art.

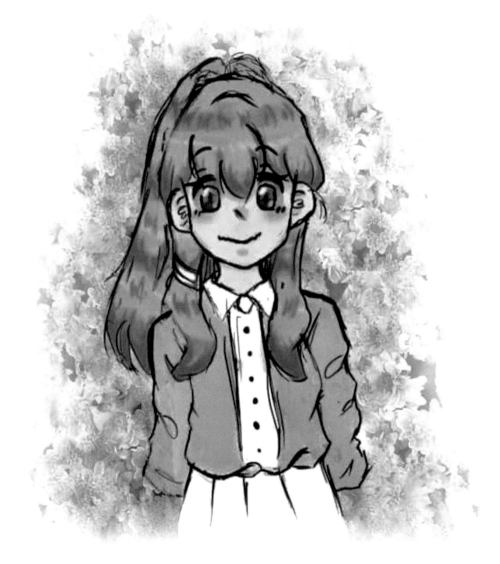

Her name is **Kim**. As one of my first completed drawings to be done in Photoshop with my Wacom drawing tablet, I would want that typical main character school girl and this is how it turned out. Her hair, which I'm proud of, is a high ponytail that is spread out with some excess hair out with tips that is waved and on one side was a white colored band. For the shading of the hair, which I wasn't really sure how to do, probably took the longest since I'm not that familiar with Photoshop's functions so I just winged it so I could actually finish the hair. Now for the clothes, she has a white t-shirt with a loose grey jacket to cover the t-shirt and a white skirt for the bottom. The background was made with this brush on Photoshop which was a bunch of flowers, so I covered a part behind the character with the brush with the color grey, then added a layer and clipped it over and used another brush to cover over it with different colors since I didn't find an airbrush to use. Kim's personality as that of "typical MC school girl" would be bubbly and kind based on how I drew her.

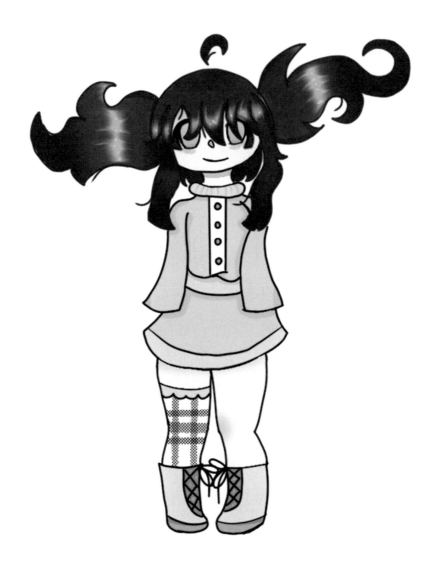

I haven't figured out her name yet, but it's fine. This is when I tried to do alternate art style but then I realized I didn't really do well, so I ended up changing the color scheme of the drawing into this, which I thought *"hey this drawing kinda looks like* **Gon***, but female* **Gon** *from Hunter x Hunter (Hunter x Hunter is an anime) ..."*. For the hair, I wanted to try something new so I put some high ponytails that had gel so it would stay up that way. The shading I'd say, it's okay?? At that time, I didn't really find a good way of shading hair so I just did something random. The clothing is supposed to be for winter but then I could not draw stockings and also drawing long skirts was a bit hard for me since I couldn't really find a design that would suit the top, and also since I don't know how to shade clothes yet, I just did a bit of shadow.

This is my first drawing that wasn't traced. Before, on my first year of digital art, I used to draw a sketch on my notebook, then took a picture, then imported it on *Ibis* paint and trace the outline. But then one day, I was trying to do a mini sketch of something, then it turned pretty good. Her hair is inspired by a hair shading tutorial I watched so I tried to make it look like the tutorial, but it looked like this, but it's okay since it doesn't look bad. The face is pretty simple, I just used a simple smile with simple eyes to prevent my first ever drawing that wasn't traced too complicated for me. The clothes were inspired by a clothing set which the mannequin wore a white blouse and on top was a black tank top that sort of looked like a corset with a ruffled skirt to top it off. I also tried to draw some thigh-high socks with some opaque rain boots. She was supposed to be holding an umbrella but then again I tried to keep the drawing as simple as possible.

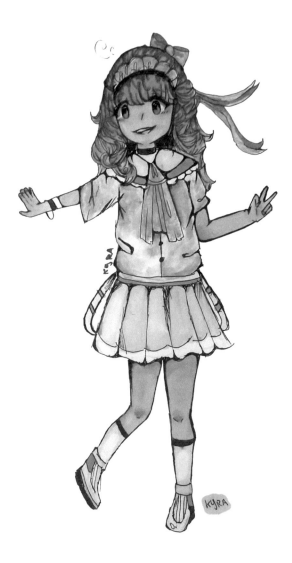

It's really detailed. She is basically **Kim**, but different. I added a change to the typical uniform I would draw like the collar which now has a lace at the tips and they now have a hat or a ribbon and by the waist, there is a belt and also the necktie. The color which I attempted to do with watercolor pencils, I scribbled on the color, wet my brush and stroked the scribble and then I realized the paper of course wasn't suitable for water color. I'm not sure how I managed to fix it, but that's what it looks like now. The hair, I had to choose between a red-orange *ombre* or a red-yellow so I just went for red-orange since I thought it would look better than the other. So yeah, her pose was supposed to be her running and waving bye with a peace sign, but then the pose looked so stiff so now it just looks like her standing and doing a weird pose. Also, I must mention I suck at drawing hands and legs, so I really had a difficult time drawing them. The medium I used is alcohol based markers and they work pretty well. *I AM REALLY PROUD OF HER HAIR!*

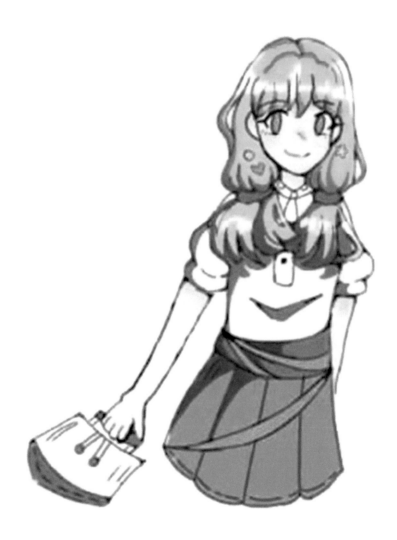

About this art, I got a bit disappointed at this since it took around 3 hours and it's only this much, compared to now, I can make drawings better than that in just 1 hour but that probably mean I got better? I think the explanation to why it took so long is because I was trying a new art style which was to fill in the whole thing with grey and just clip some layers to change the colors, just like how I did on Kim's background (insert the page Kim's description is in). Moving on from the complaining, I think the art is quite nice, a girl with short pigtails and holding a bag. For the hair, the shading was pretty simple since I only used multiply and add clipped layers. For the clothes, it's the same. This is one of the arts where it shows majority of my art style forming. Her top is a plain white shirt with buttons and puffy sleeves and the skirt has a little piece of clothing that wraps around her waist like a belt.

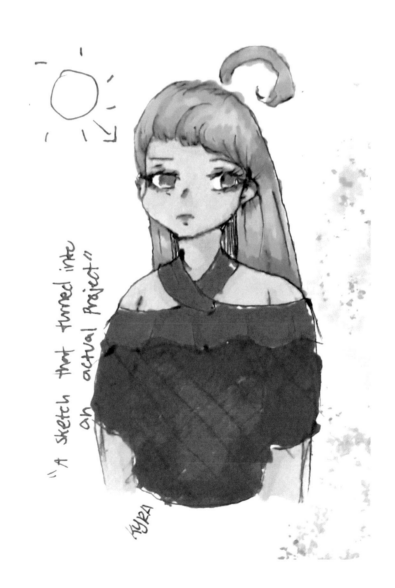

"A sketch that turned into an actual project"

KYRA

This is inspired by Teka which is from MHA/BNA. Teka is the grandmother of Shotou Todoroki. As it said on the caption beside it, it was supposed to be only a sketch. Then when I colored her shirt, I had a need to color the rest. The hair is green because I wanted something new. Her clothes are an off shoulder with a clothing wrapping around her neck as a strap.

Printed in the United States
by Baker & Taylor Publisher Services